TWO
OF A KIND

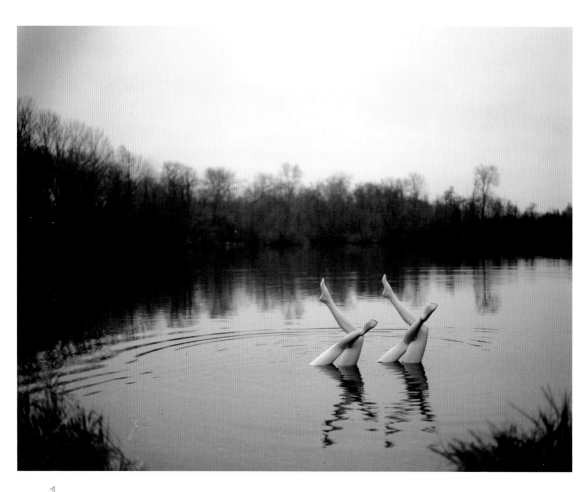

PLATE 1　JEAN-BAPTISTE COURTIER

TWO
OF A KIND

SANDRINE KERFANTE

CHRONICLE BOOKS

SAN FRANCISCO

Library of Congress Cataloging-in-Publication Data:

Names: Kerfante, Sandrine, author.

Title: Two of a kind / by Sandrine Kerfante.

Description: San Francisco : Chronicle Books, [2016]

Identifiers: LCCN 2015037475 | ISBN 9781452140162

Subjects: LCSH: Photography of twins.

Classification: LCC TR681.T85 K47 2016 | DDC 779.2—dc23 LC
record available at http://lccn.loc.gov/2015037475

Manufactured in China

Design by Sara Schneider

10 9 8 7 6 5 4 3 2 1

Chronicle Books LLC
680 Second Street
San Francisco, California 94107

www.chroniclebooks.com

*Chronicle books and gifts are available at special quantity discounts
to corporations, professional associations, literacy programs, and other
organizations. For details and discount information, please contact our
corporate/premiums department at corporatesales@chroniclebooks.com
or at 1-800-759-0190.*

ACKNOWLEDGEMENTS

FIRSTLY, I WOULD LIKE TO THANK
ALL THE PHOTOGRAPHERS WHO
HAVE CONTRIBUTED TO THIS BOOK.

I WOULD ALSO LIKE TO EXPRESS
MY GRATITUDE TO MY EDITOR,
BRIDGET WATSON PAYNE.

THANK YOU TO MY GREAT FRIENDS
AND LOVELY FAMILY!

FINALLY, A SPECIAL THANK YOU
TO CAMILLE DUFOUR, NIK SO, AND
DANIELLE KRYSA.

I DEDICATE THIS BOOK TO MY MUM.

INTRODUCTION

SANDRINE KERFANTE

The double—this other self—sometimes a symbol of conformity, sometimes otherness, awakens fascination, questioning, and wariness in those who contemplate it. Being a daughter of a twin mother, from an early age I have found twins to be a source of amusement and perplexity.

When I was a young child, it was really amazing to discover the perfect double of my mum.

Who's this twin, then, if she isn't a mirror? A me double? Why is symmetry so comforting but also so annoying? Why is the idea of the double so fascinating and troubling at the same time?

For me, it was in an exhibition I saw a few years back, dedicated to the work of the photographer Francesca Woodman, that all became clear. In particular, there was a self-portrait of the artist reflected in a mirror. For a long time, I kept a photo of this portrait that had moved me deeply on my bedroom wall. Then, slowly, I took to collecting and curating images on the themes of reflection, doubles, symmetry, and twins. Eventually I ended up starting a blog to house my image collection. Called "Twin-niwt," a title that evokes the mirror effect and the oddity of double, my blog became the outward manifestation of my long-running preoccupation with these sorts of images, a place for me to present photographs that grapple with the questions I'd so long been fascinated by: Who is the double? And what about me, who am I? The double brings up, first and foremost, the question of identity.

These shots are the witnesses to the great paradox of the double: one after another they beckon, offering both reconciliation and opposition.

Looking at such images awakens identity angst while at the same time soothing it.

Even if we are not twins, and don't have friends or relatives in our lives who are twins, we've all experienced that close bond with another—often a sister or a girlfriend—where two people become so close they start to mirror one another. As disconcerting as that experience can sometimes be, it is also wonderful to feel we are seen and understood in that way. A double both imitates and betrays the original. A subject and its double are thus intertwined, interdependent, each legitimizing the other.

This book offers a personal view on contemporary photography through the prism of the double. These talented photographers whose work I've gathered come from different countries and cultivate their own universes. While not alike, they complement each other. From portraits of real twins or people with similar attitudes to double self-portraits or symmetrical landscapes, each of these images tries to bring its own response to the question (or the game) of the double.

Are you ready to explore your own reaction to these images? To contemplate doubleness in your own relationships—your own identity? Together let us explore the beauty and mystery of symmetry.

Let's see life in doubles!

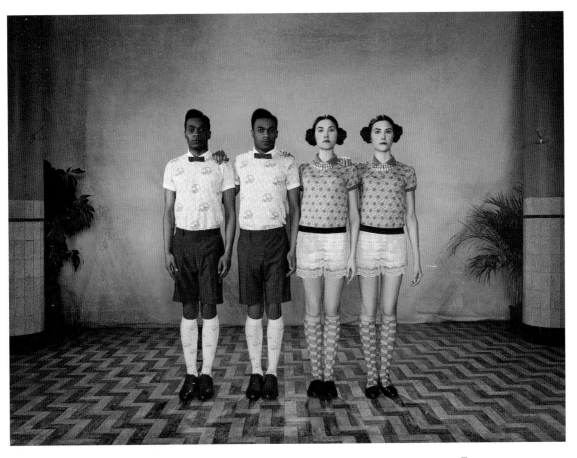

PLATE 2 FRIEKE JANSSENS

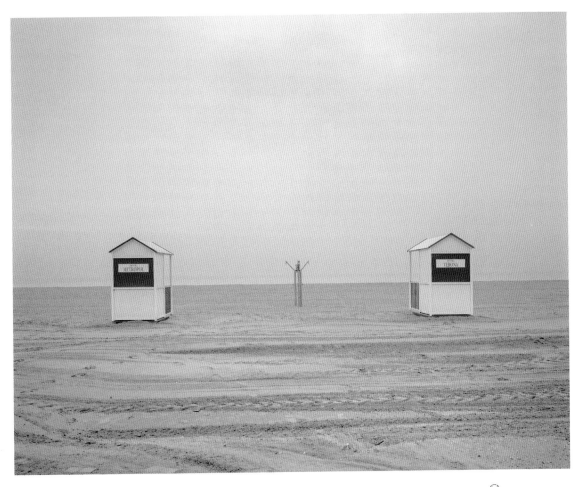

PLATE 3 AKOS MAJOR

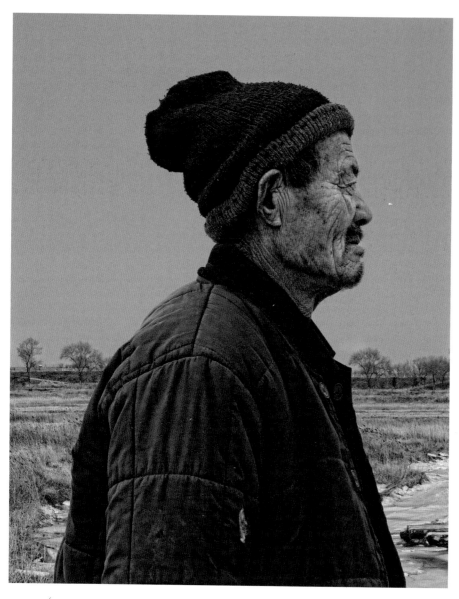

PLATE 4 GAO RONGGUO

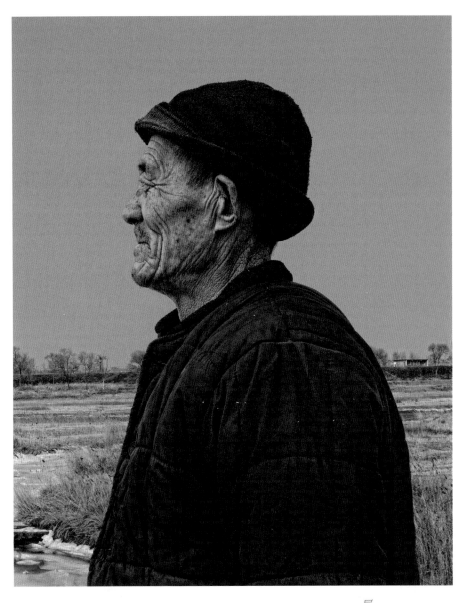

PLATE 5 GAO RONGGUO

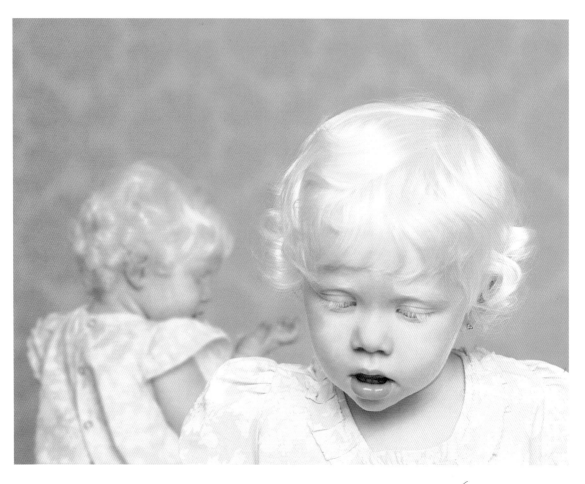

PLATE 6 GUSTAVO LACERDA

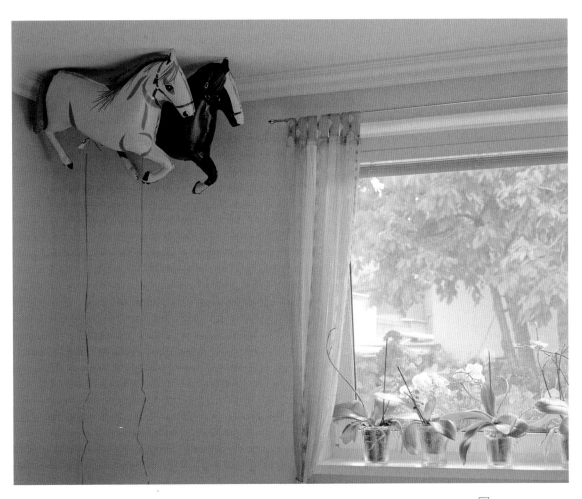

PLATE 7 LUKAS CETERA

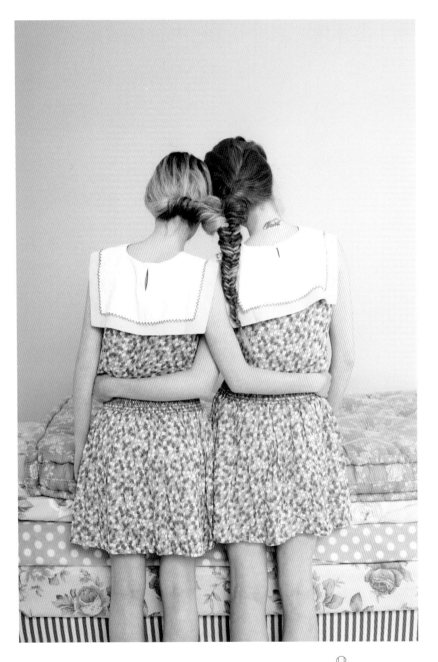

PLATE 8 ANAÏS KUGEL

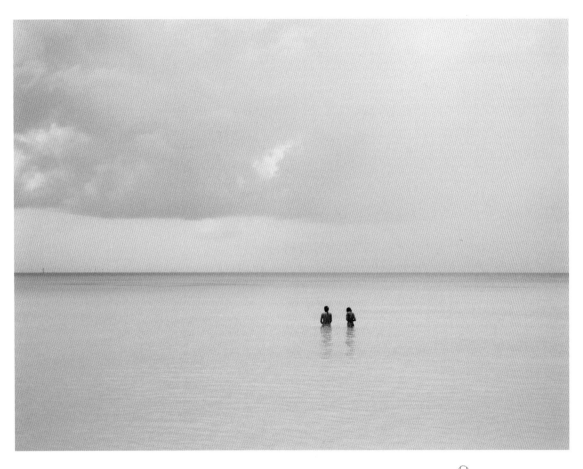

PLATE 9 JOSEF HOFLEHNER

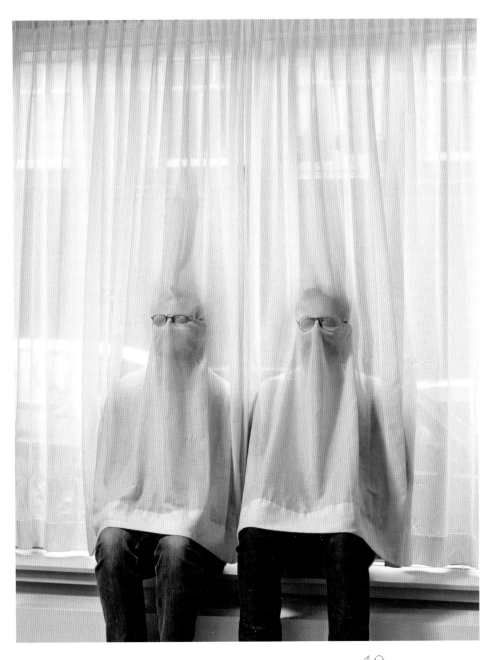

PLATE 10 JOUK OOSTERHOF

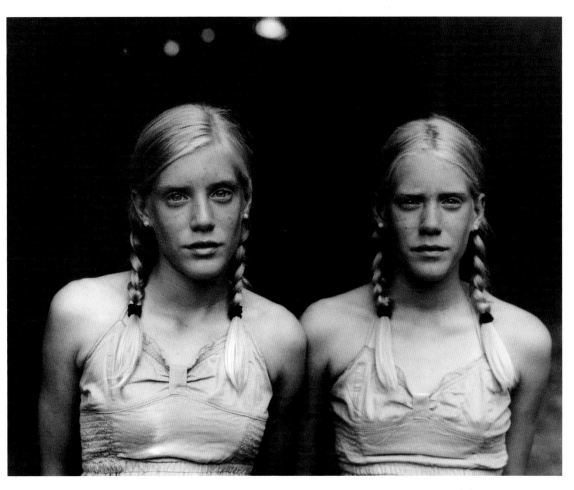

PLATE 11 WILLIAM HACKER

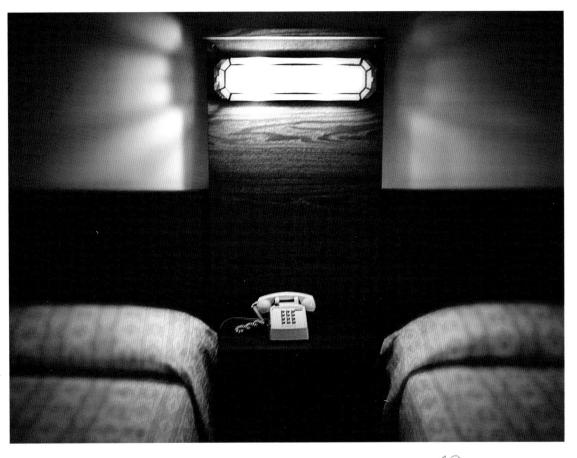

PLATE 12 MYMOODYPICTURES

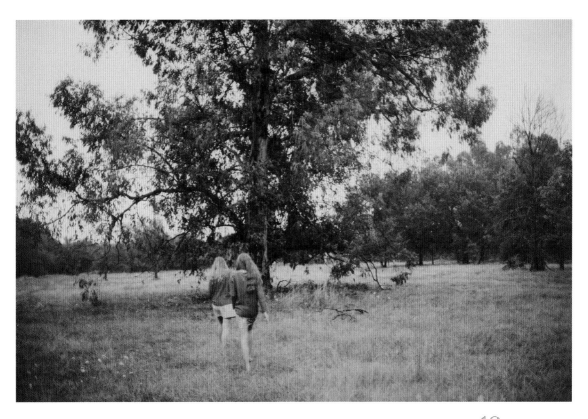

PLATE 13 ANAÏS KUGEL

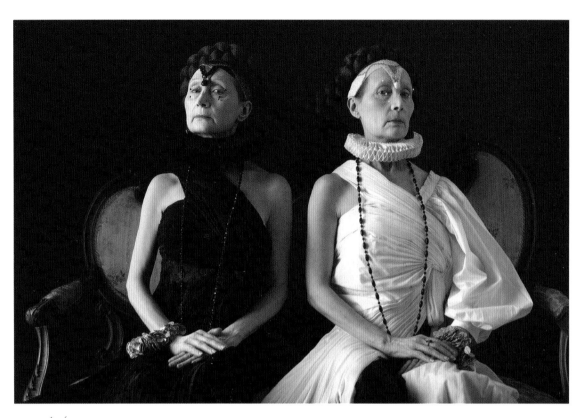

PLATE 14 BENOIT MAUDUECH

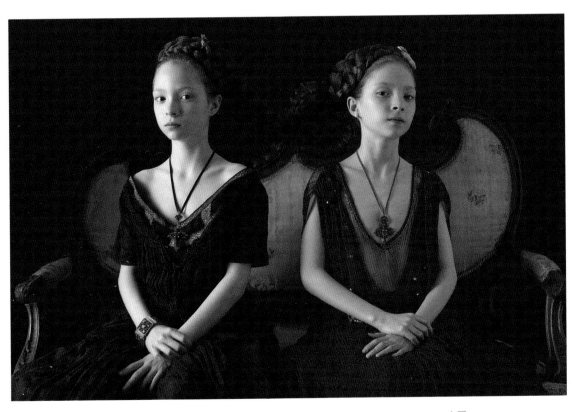

PLATE 15 BENOIT MAUDUECH

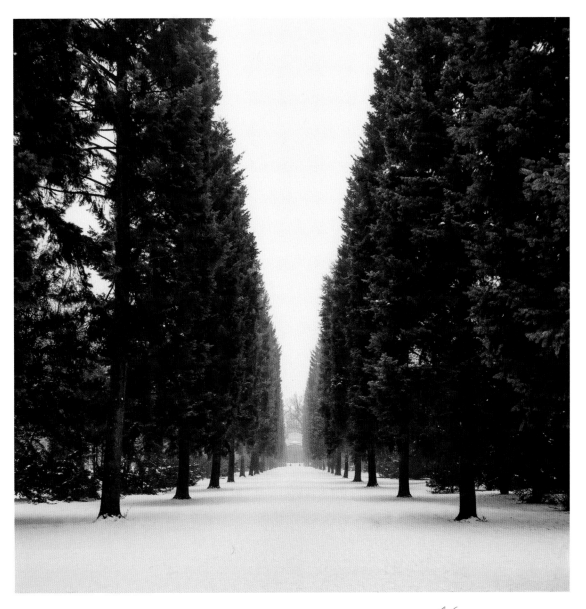

PLATE 16 MATTHIAS HEIDERICH

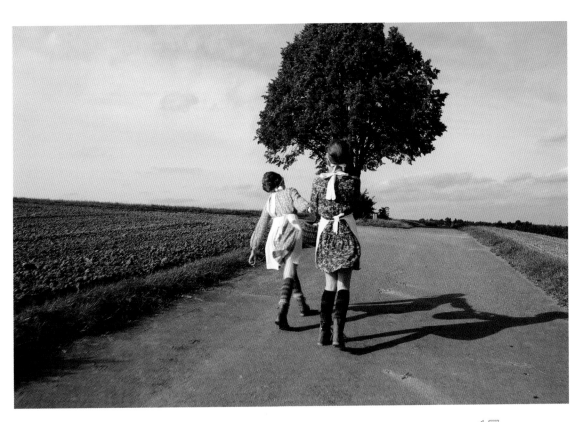

PLATE 17 JULIA BLANK

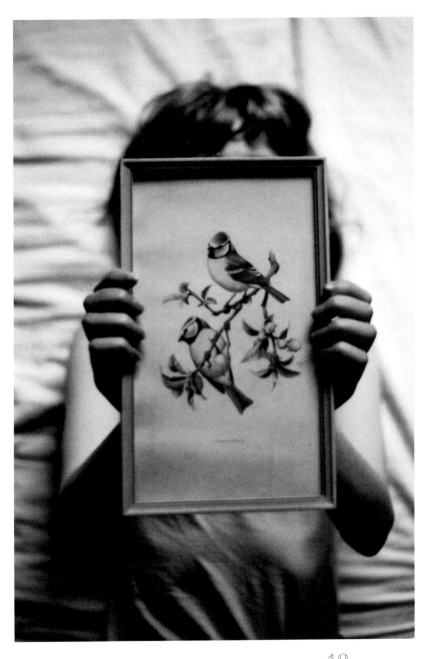

PLATE 18 TINA SOSNA

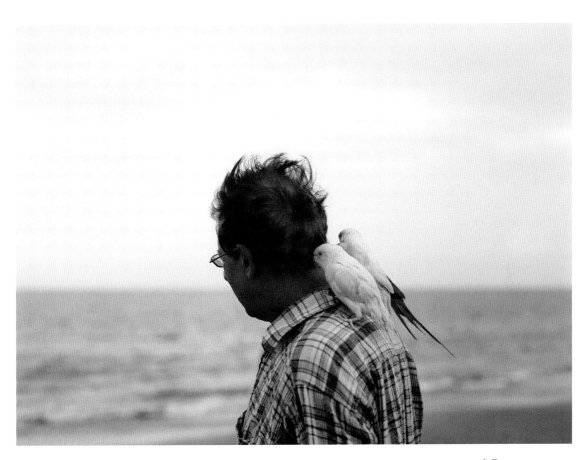

PLATE 19 SAMM BLAKE

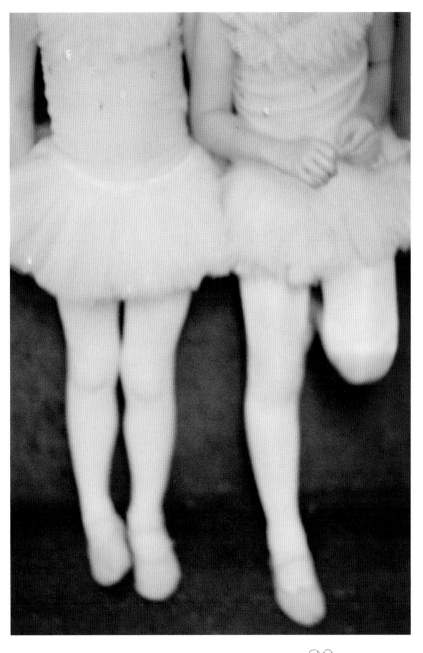

PLATE 20 LISA CANDELA

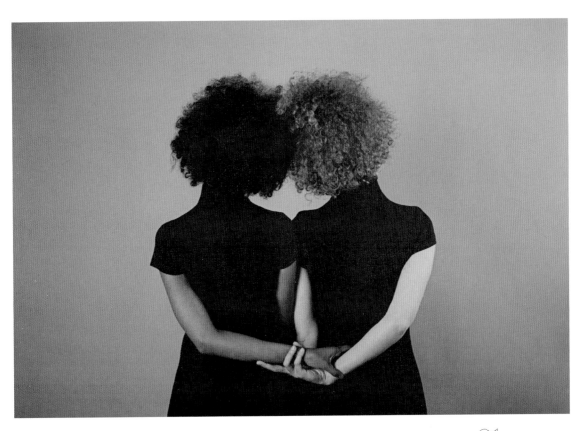

PLATE 21 ALMA HASER

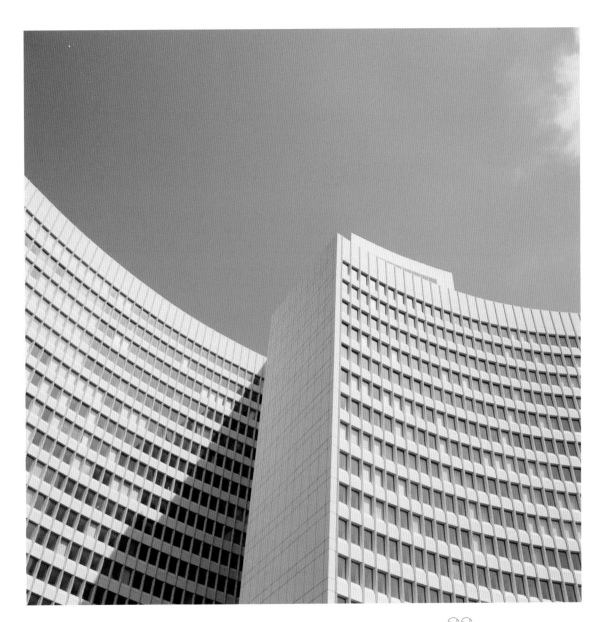

PLATE 22 MATTHIAS HEIDERICH

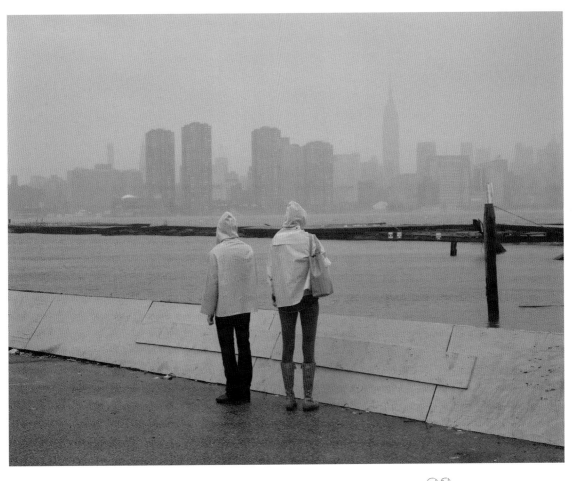

PLATE 23 MATTHEW SCHENNING

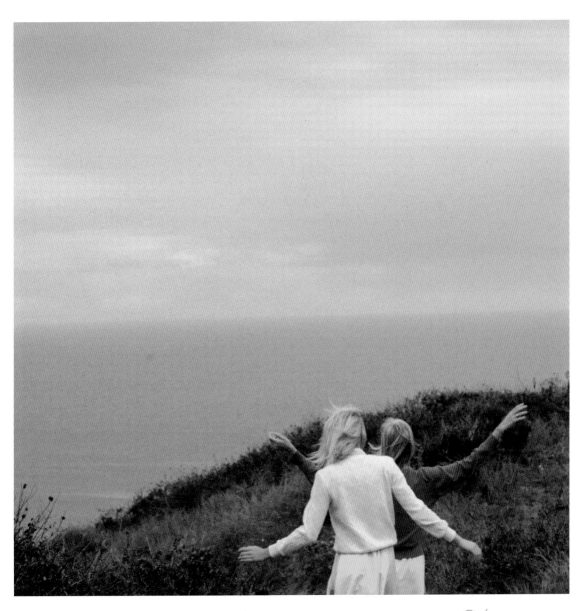

PLATE 24 JIMMY MARBLE

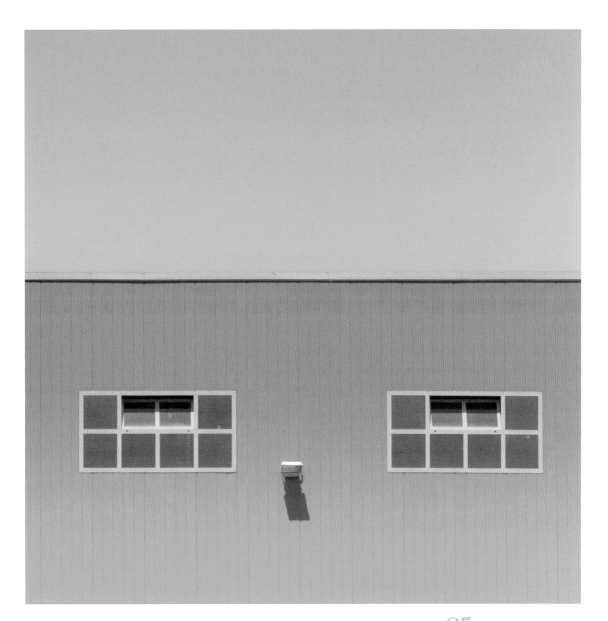

PLATE 25 VITTORIO CICCARELLI

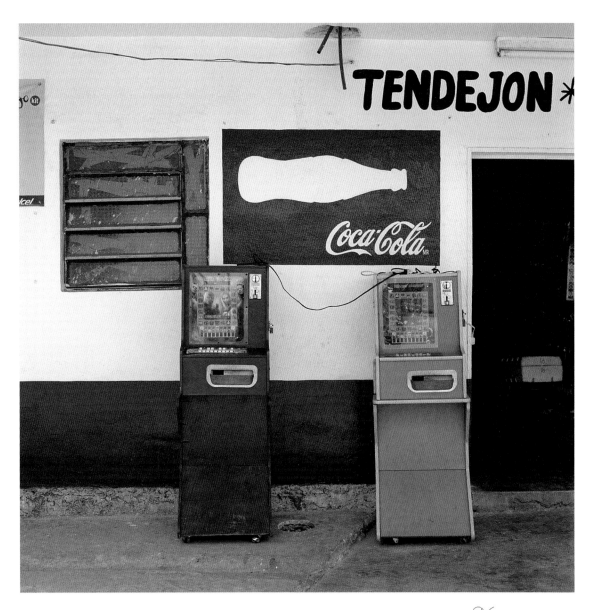

PLATE 26 ANDREA ILLÁN

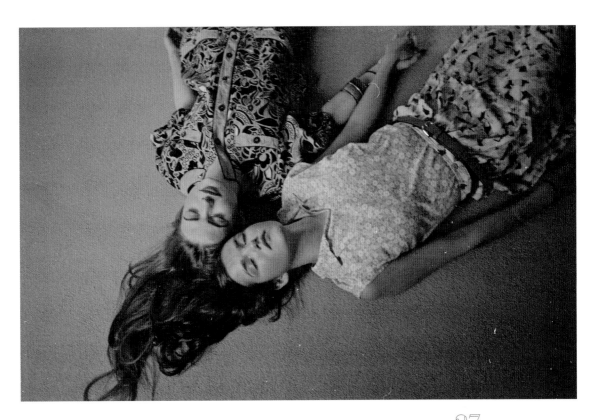

PLATE 27 JASMINE DEPORTA

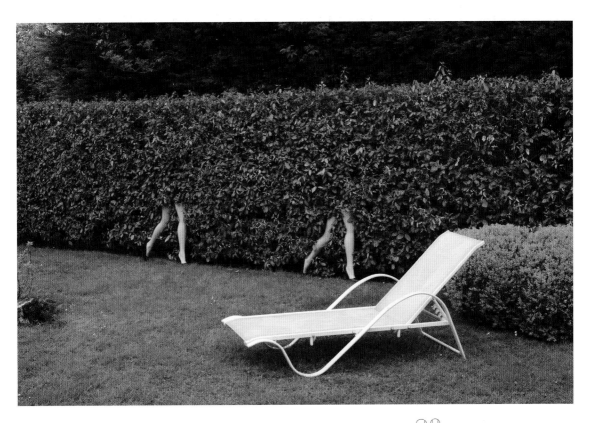

PLATE 28 JEAN-BAPTISTE COURTIER

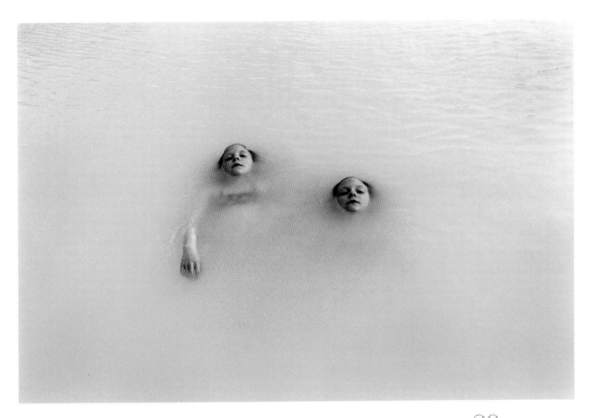

PLATE 29 ARIKO INAOKA

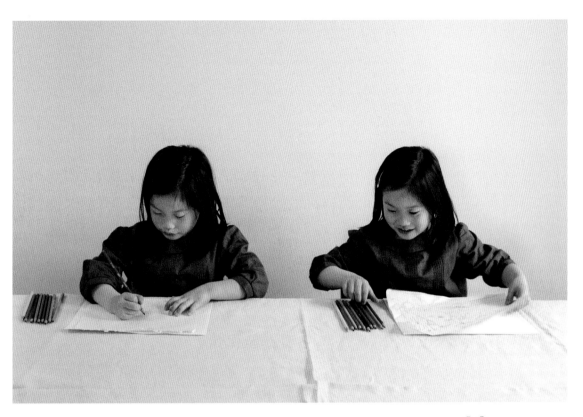

PLATE 30 REIKO NONAKA

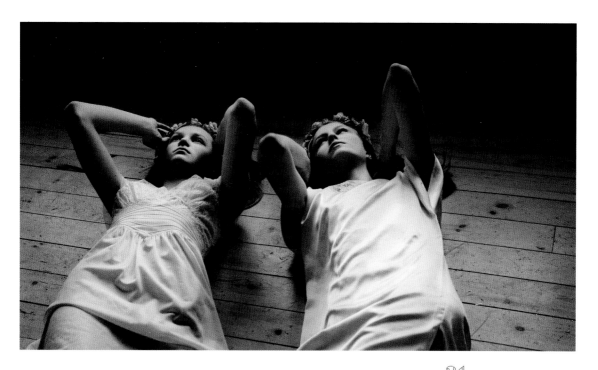

PLATE 31 JESSICA SILVERSAGA

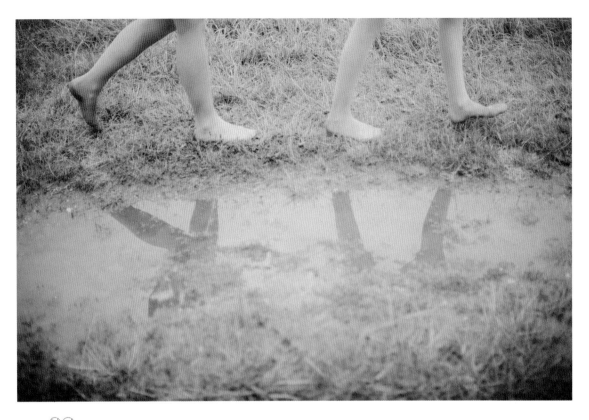

PLATE 32 ANAÏS KUGEL

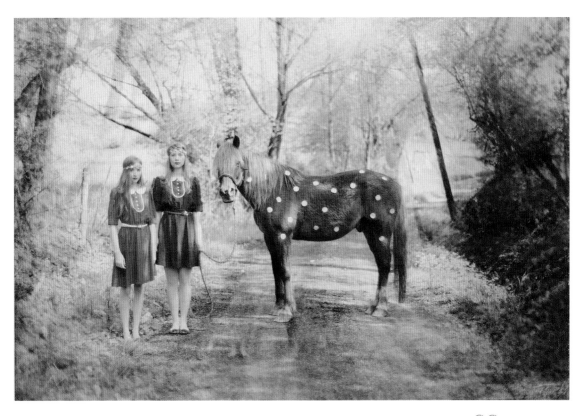

PLATE 33 ANAÏS KUGEL

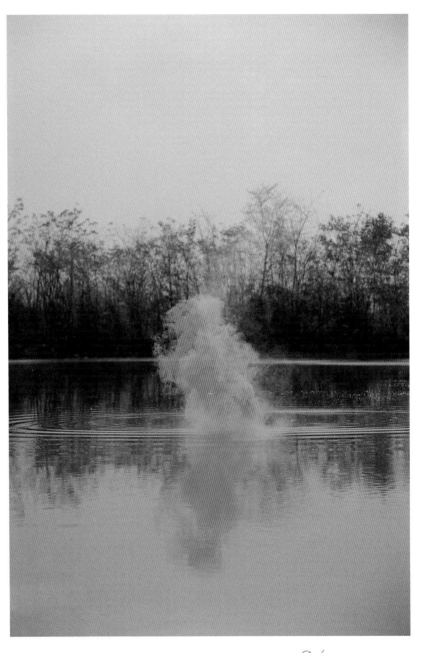

PLATE 34 FILIPPO MINELLI

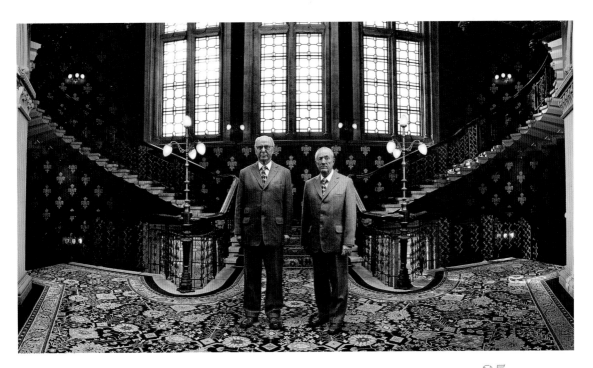

PLATE 35 ANDY TEARE

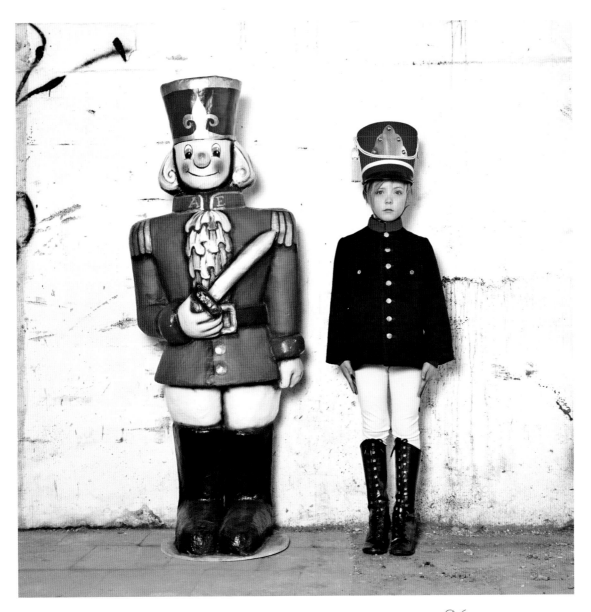

PLATE 36 EMILIE VERCRUYSSE

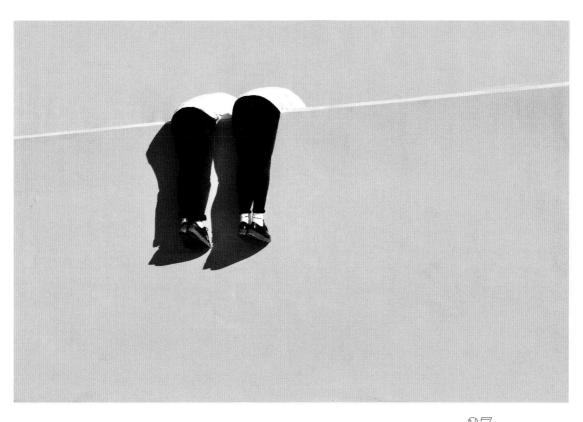

PLATE 37 KOSTIS FOKAS

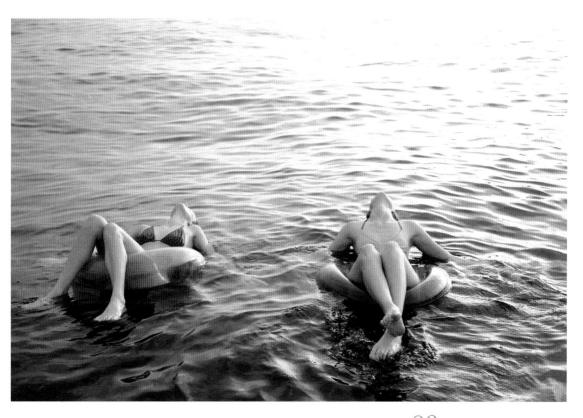

PLATE 38 THAYER ALLYSON GOWDY

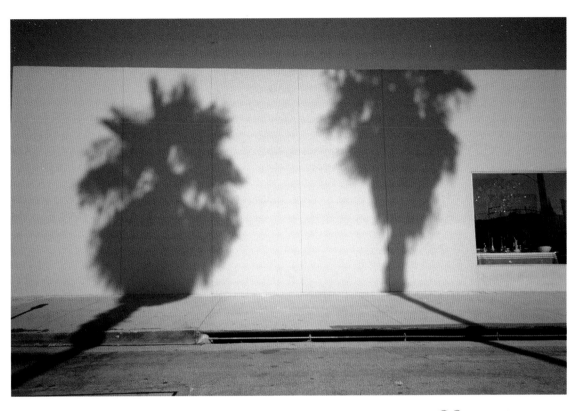

PLATE 39 DARREN ANKENMAN

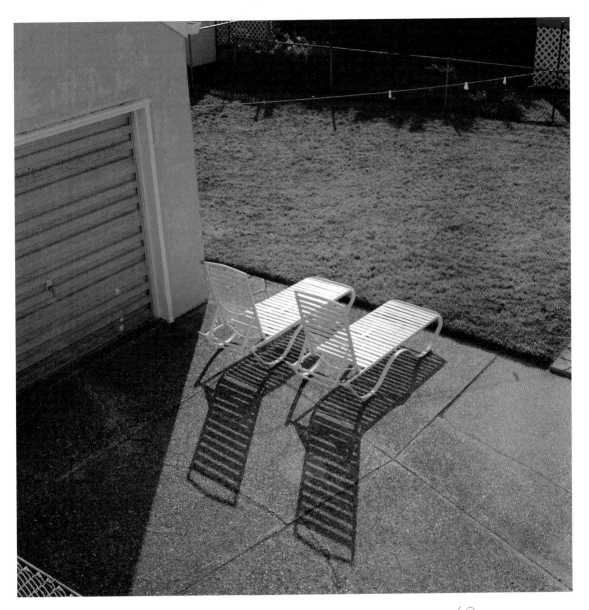

PLATE 40 RACHEL RINEHART

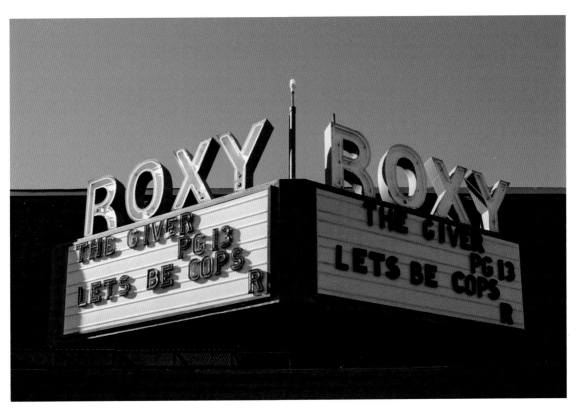

PLATE 41 GAÉTAN ROSSIER

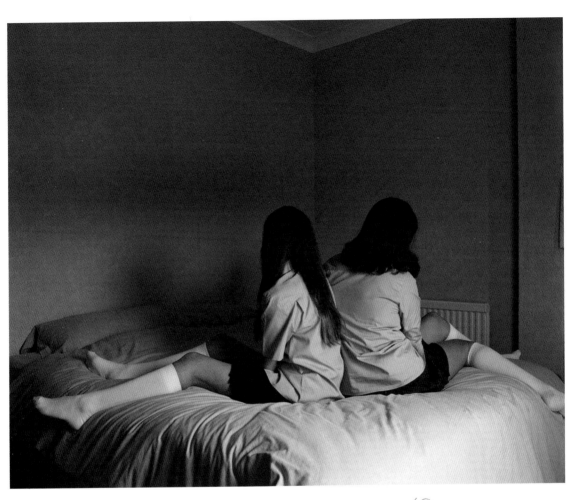

PLATE 42 JULIA FULLERTON-BATTEN

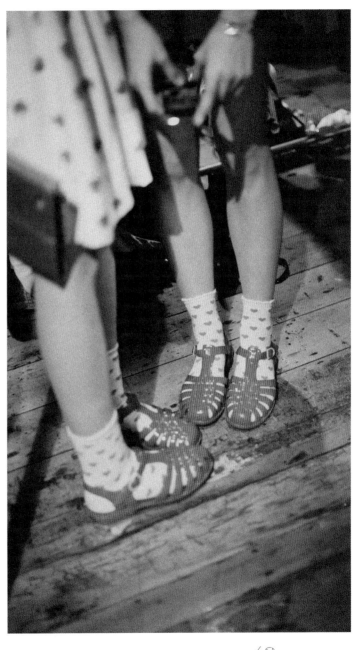

PLATE 43 JEANNINE TAN

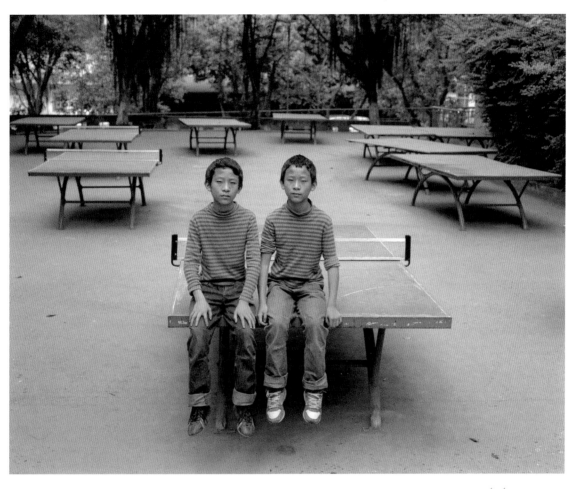

PLATE 44 JIEHAO SU

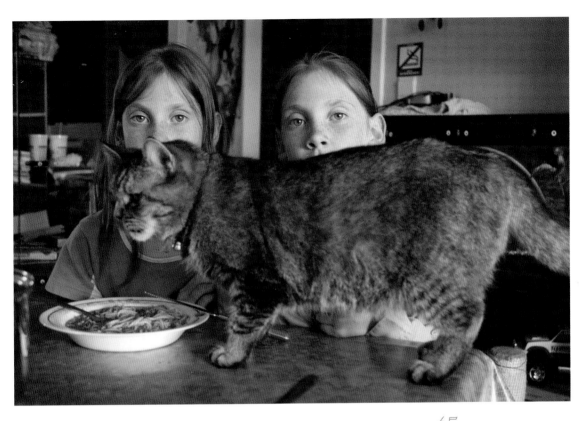

PLATE 45 AN-SOFIE KESTELEYN

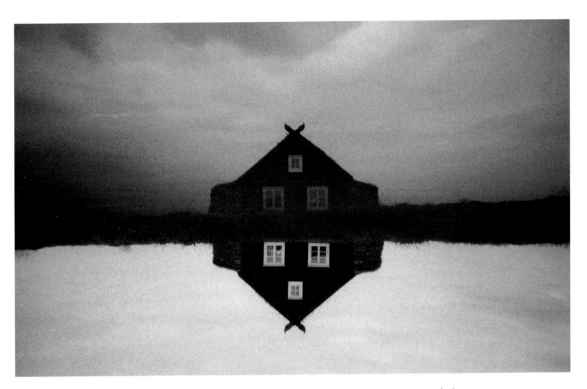

PLATE 46 KRISTINA PETROŠIUTĖ

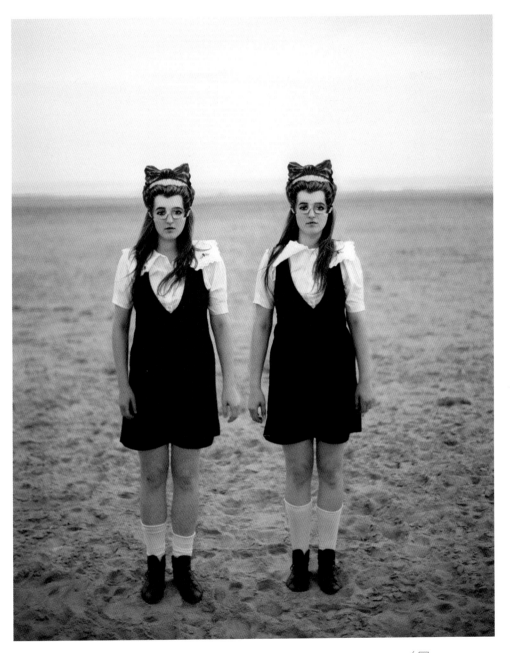

PLATE 47 MAIA FLORE

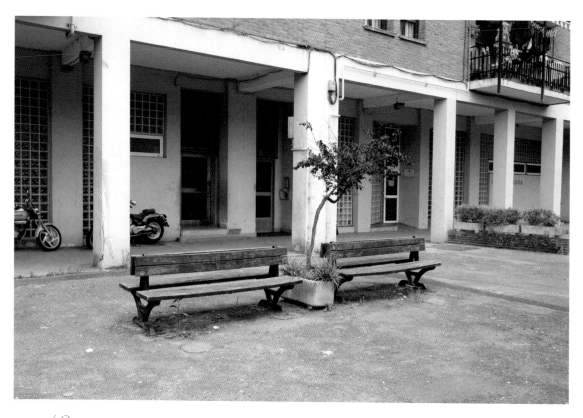

PLATE 48 GAÉTAN ROSSIER

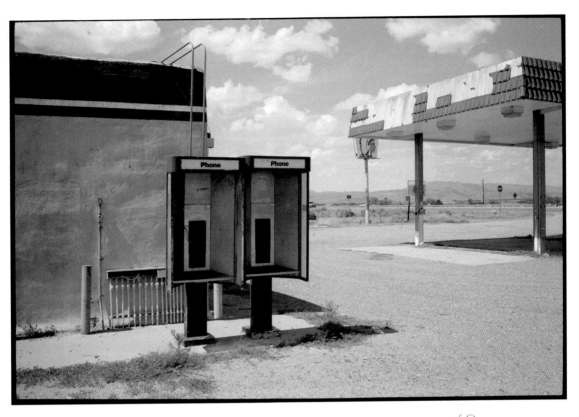

PLATE 49 GAËTAN ROSSIER

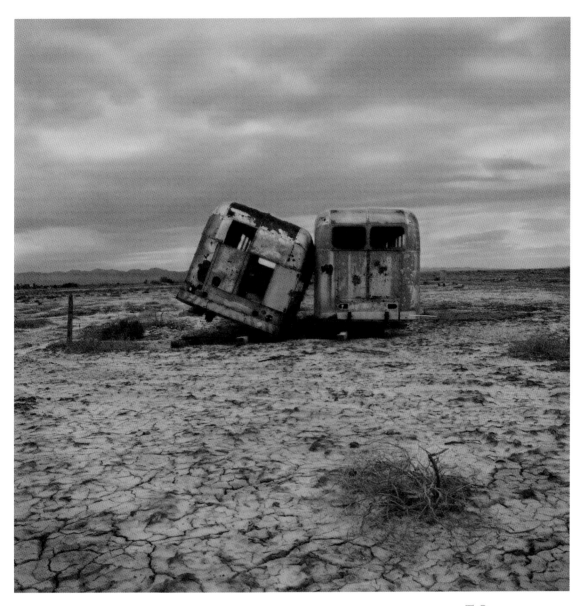

PLATE 50 RAY CAROFANO

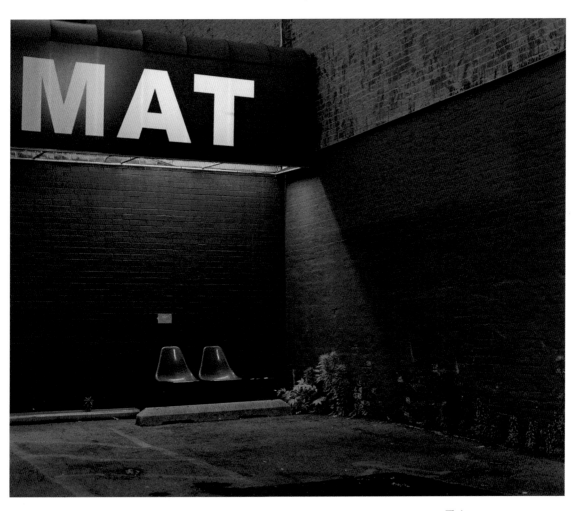

PLATE 51 CARSON GILLILAND

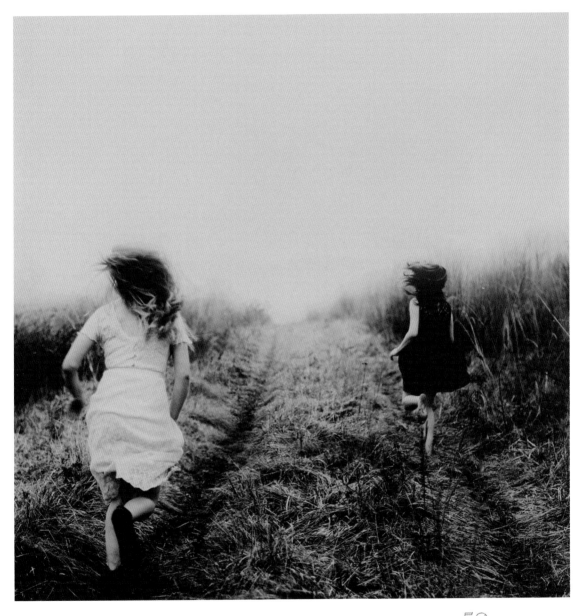

PLATE 52 HAILEY HEATON

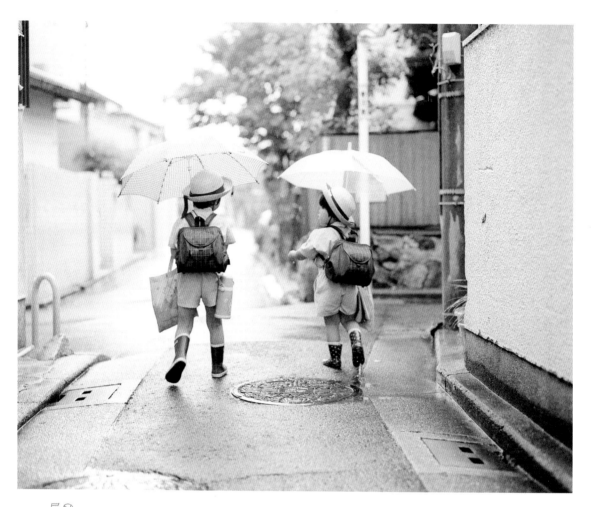

PLATE 53 HIDEAKI HAMADA

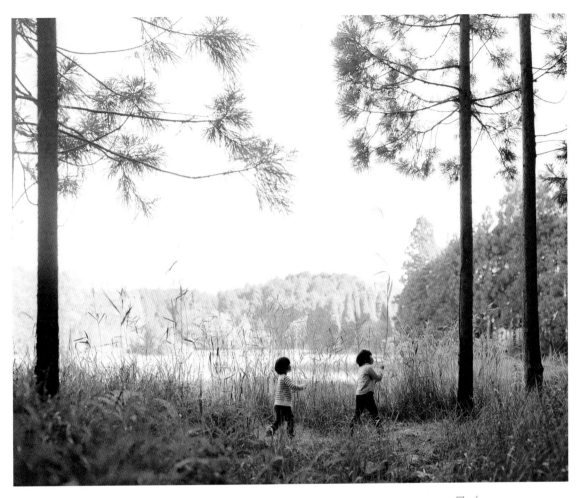

PLATE 54 HIDEAKI HAMADA

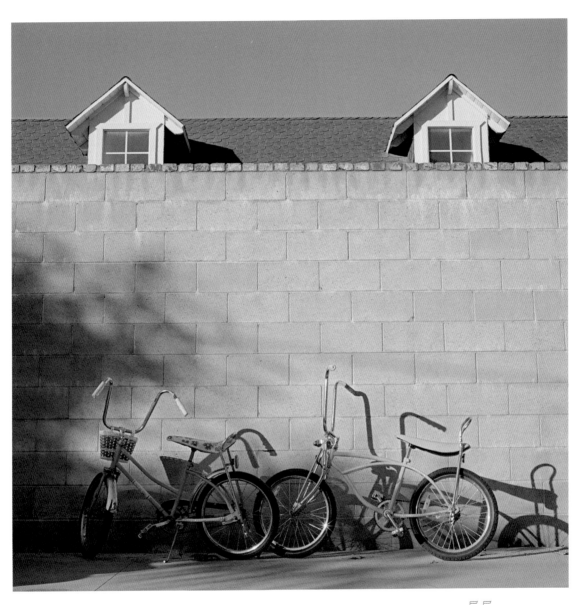

PLATE 55 AARON RUELL

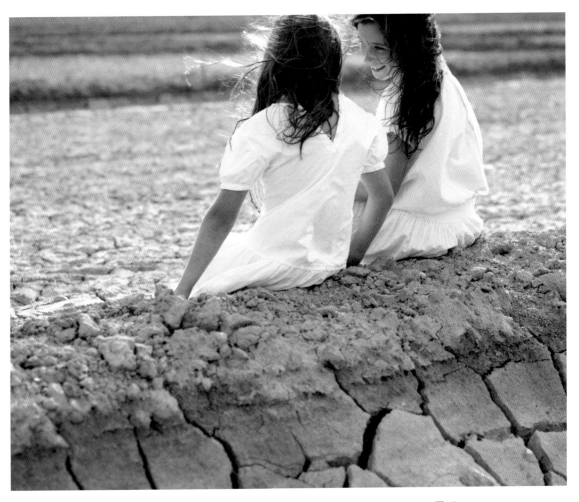

PLATE 56 MÉLANIE RODRIGUEZ

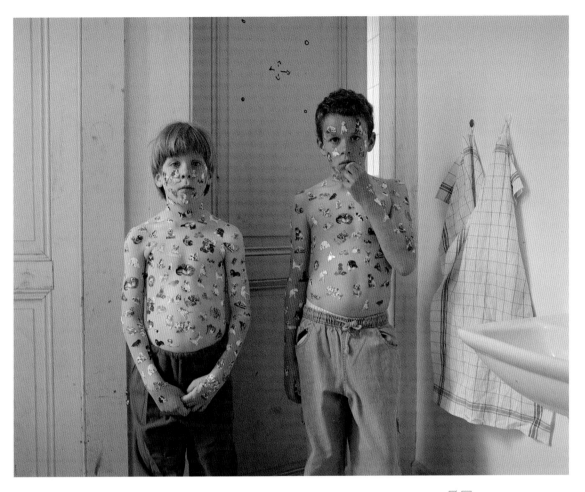

PLATE 57 THOMAS ROUSSET

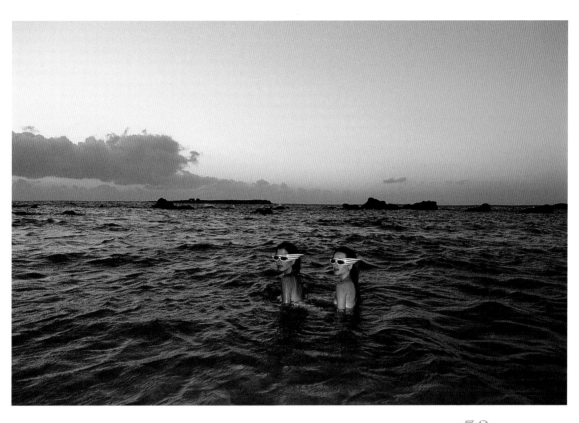

PLATE 58 KOSTIS FOKAS

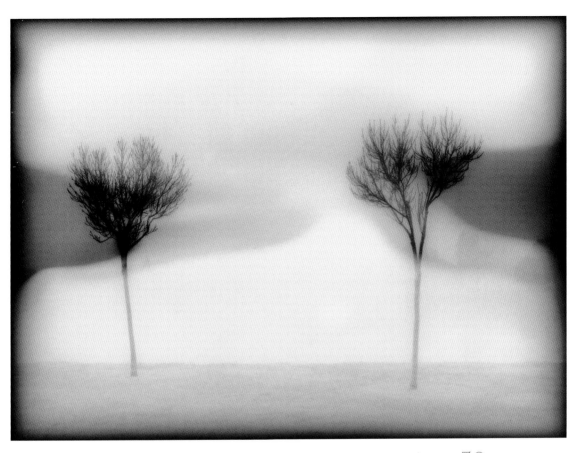

PLATE 59 RAY CAROFANO

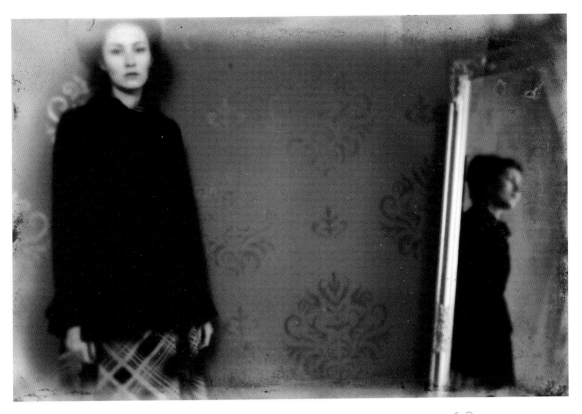

PLATE 60 ROBERT HUTINSKI

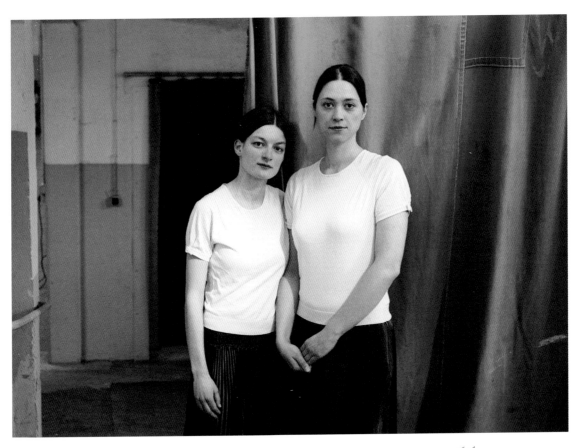

PLATE 61 KATHARINA LEPIK

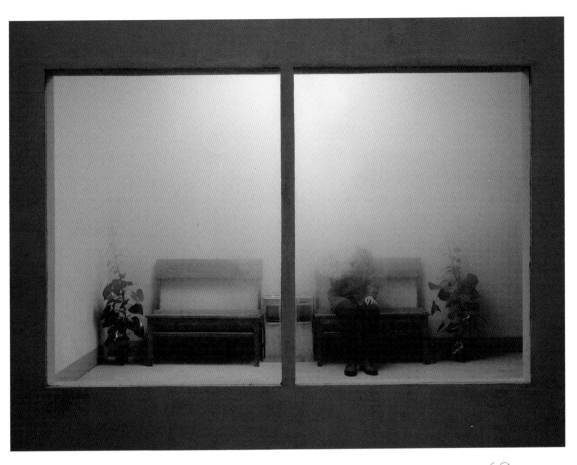

PLATE 62 CHEN WEI

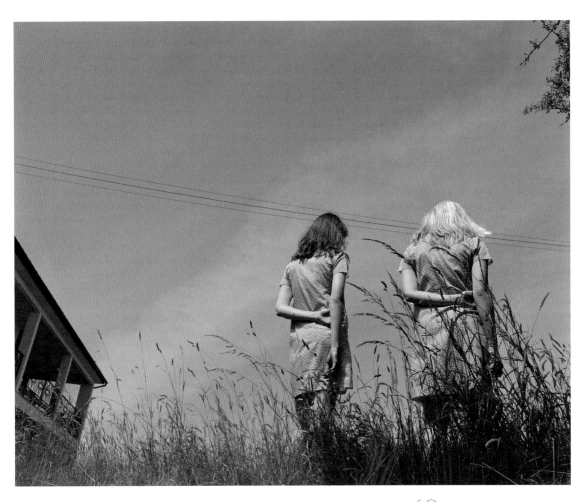

PLATE 63 JULIA FULLERTON-BATTEN

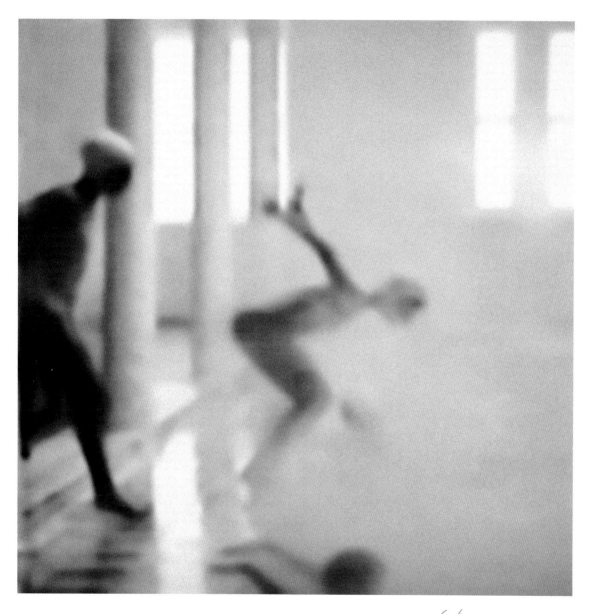

PLATE 64 FLORENCE DOUYROU

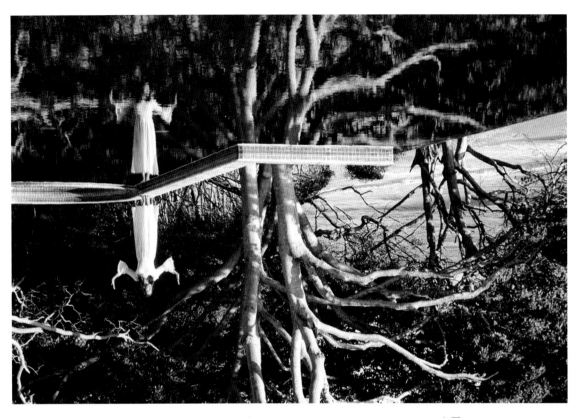

PLATE 65 AMANDA CHARCHIAN

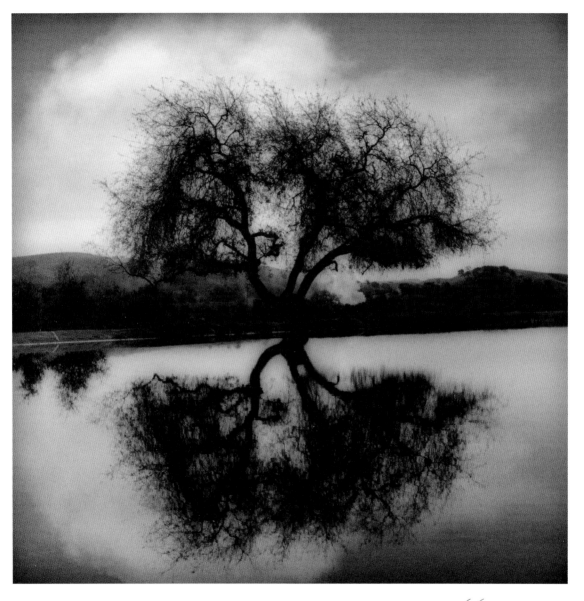

PLATE 66 RAY CAROFANO

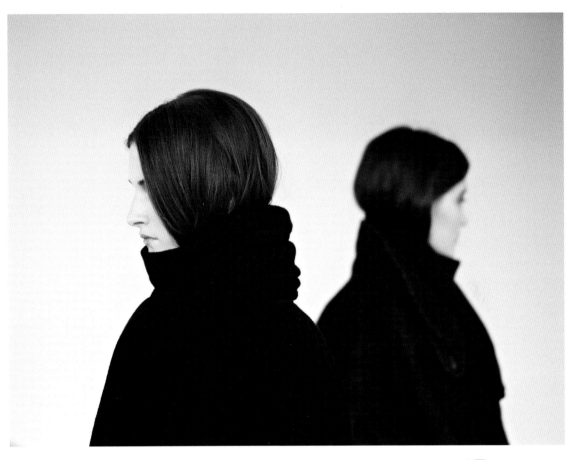

PLATE 67 NICOLAS SISTO

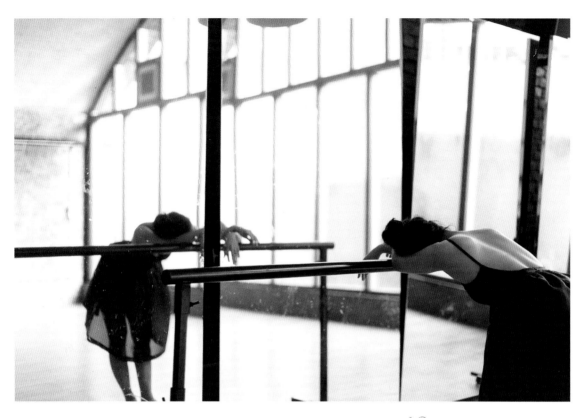

PLATE 68 SHINI PARK OF PARK & CUBE

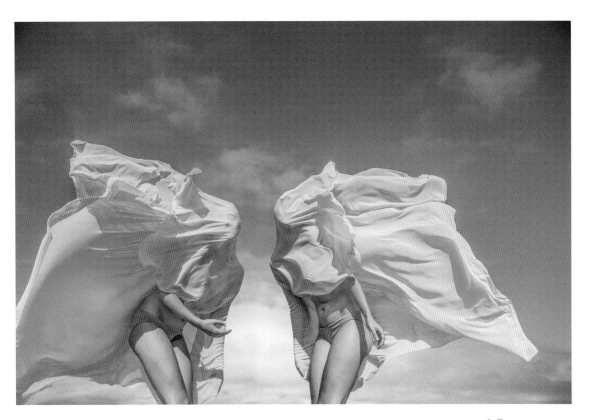

PLATE 69 PRUE STENT

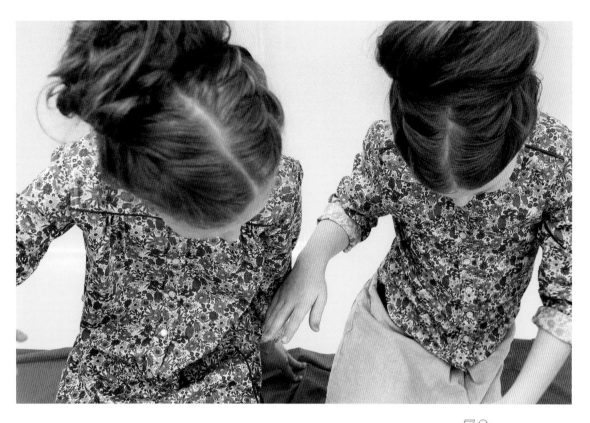

PLATE 70 PAULA PERRIER

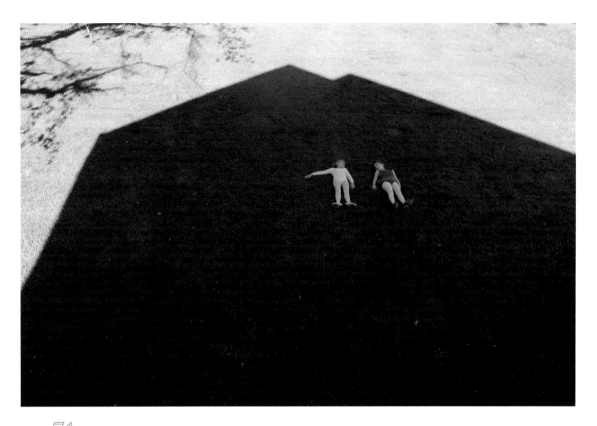

PLATE 71 POLLY GAILLARD

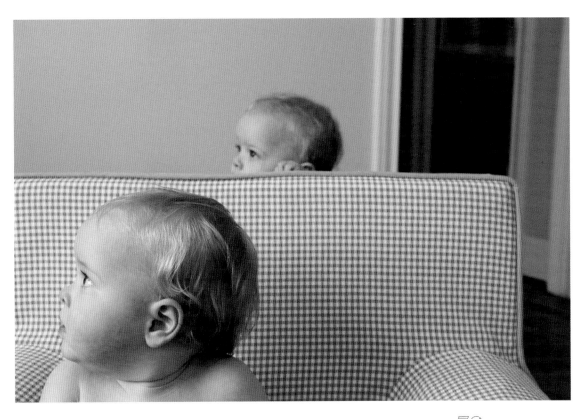

PLATE 72 POLLY GAILLARD

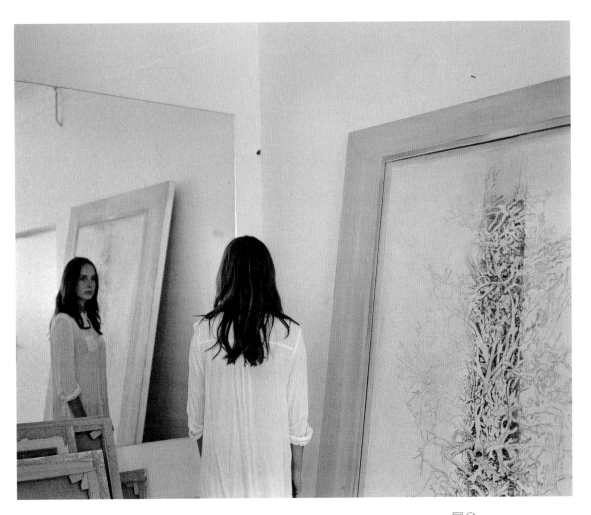

PLATE 73 JASMINE DEPORTA

ART CREDITS

PLATE 1
JEAN-BAPTISTE COURTIER
www.jeanbaptistecourtier.com

PLATE 5
GAO RONGGUO
www.artist.cn/gaorongguo

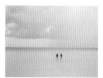

PLATE 9
JOSEF HOFLEHNER
www.josefhoflehner.com

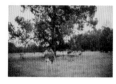

PLATE 13
ANAÏS KUGEL
www.anaiskugel.com

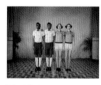

PLATE 2
FRIEKE JANSSENS
www.frieke.com

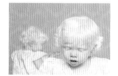

PLATE 6
GUSTAVO LACERDA
www.gustavolacerda.com.br

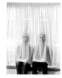

PLATE 10
JOUK OOSTERHOF
www.joukoosterhof.nl

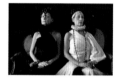

PLATE 14
BENOIT MAUDUECH
www.benoitmauduech.com

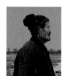

PLATE 3
AKOS MAJOR
www.akosmajor.com

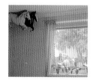

PLATE 7
LUKAS CETERA
www.lukascetera.com

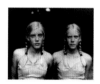

PLATE 11
WILLIAM HACKER
www.williamhackerphoto.com

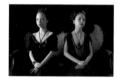

PLATE 15
BENOIT MAUDUECH
www.benoitmauduech.com

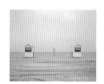

PLATE 4
GAO RONGGUO
www.artist.cn/gaorongguo

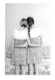

PLATE 8
ANAÏS KUGEL
www.anaiskugel.com

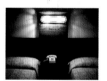

PLATE 12
MYMOODYPICTURES
www.mymoodypictures.tumblr.
com

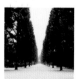

PLATE 16
MATTHIAS HEIDERICH
www.matthias-heiderich.de

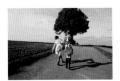

PLATE 17
JULIA BLANK
www.juliablank.allyou.net

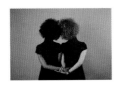

PLATE 21
ALMA HASER
www.haser.org

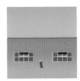

PLATE 25
VITTORIO CICCARELLI
www.vittoriociccarelli.com

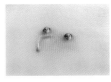

PLATE 29
ARIKO INAOKA
www.aarriikkoo.com

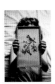

PLATE 18
TINA SOSNA
www.worteinbildern.blogspot.de

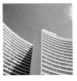

PLATE 22
MATTHIAS HEIDERICH
www.matthias-heiderich.de

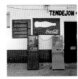

PLATE 26
ANDREA ILLÁN
www.andreaillan.com

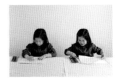

PLATE 30
REIKO NONAKA
www.reikononaka.com

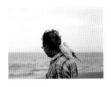

PLATE 19
SAMM BLAKE
www.sammblake.com

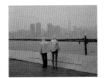

PLATE 23
MATTHEW SCHENNING
www.schenning.com

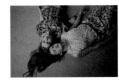

PLATE 27
JASMINE DEPORTA
www.jasminedeporta.com

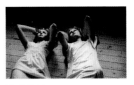

PLATE 31
JESSICA SILVERSAGA
www.silversaga.se

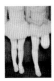

PLATE 20
LISA CANDELA
www.lisacandela.tumblr.com

PLATE 24
JIMMY MARBLE
www.jimmymarble.com

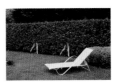

PLATE 28
JEAN-BAPTISTE COURTIER
www.jeanbaptistecourtier.com

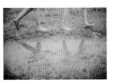

PLATE 32
ANAÏS KUGEL
www.anaiskugel.com

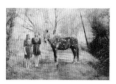

PLATE 33
ANAÏS KUGEL
www.anaiskugel.com

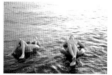

PLATE 37
KOSTIS FOKAS
www.cargocollective.com/
kostisfokas

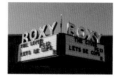

PLATE 41
GAËTAN ROSSIER
www.gaetanrossier.ch

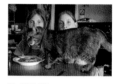

PLATE 45
AN-SOFIE KESTELEYN
www.ansofiekesteleyn.be

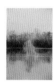

PLATE 34
FILIPPO MINELLI
www.filippominelli.com

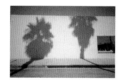

PLATE 38
THAYER ALLYSON GOWDY
www.thayergowdy.com

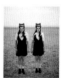

PLATE 42
JULIA FULLERTON-BATTEN
www.juliafullerton-batten.com

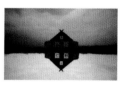

PLATE 46
KRISTINA PETROŠIUTE
www.kristinapetrosiute.com

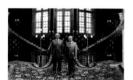

PLATE 35
ANDY TEARE
www.andytearephotography.co.uk

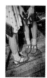

PLATE 39
DARREN ANKENMAN
www.darrenankenman.com

PLATE 43
JEANNINE TAN
www.jeanninetan.com

PLATE 47
MAIA FLORE
www.maiaflore.com

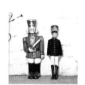

PLATE 36
EMILIE VERCRUYSSE
www.emilievercruysse.be

PLATE 40
RACHEL RINEHART
www.cargocollective.com/
rachelrinehart

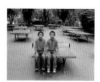

PLATE 44
JIEHAO SU
www.jiehaosu.com

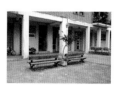

PLATE 48
GAËTAN ROSSIER
www.gaetanrossier.ch

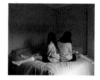

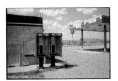

PLATE 49
GAËTAN ROSSIER
www.gaetanrossier.ch

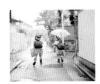

PLATE 53
HIDEAKI HAMADA
www.hideakihamada.com

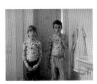

PLATE 57
THOMAS ROUSSET
www.thomasrousset.com

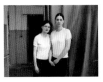

PLATE 61
KATHARINA LEPIK
www.katharinalepik.de

PLATE 50
RAY CAROFANO
www.carofano.com

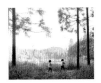

PLATE 54
HIDEAKI HAMADA
www.hideakihamada.com

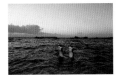

PLATE 58
KOSTIS FOKAS
www.cargocollective.com/
kostisfokas

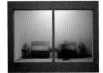

PLATE 62
CHEN WEI
www.chen-wei.org

PLATE 51
CARSON GILLILAND
www.carson-gilliland.com

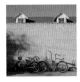

PLATE 55
AARON RUELL
www.aruell.com

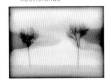

PLATE 59
RAY CAROFANO
www.carofano.com

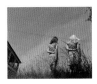

PLATE 63
JULIA FULLERTON-BATTEN
www.juliafullerton-batten.com

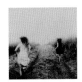

PLATE 52
HAILEY HEATON
www.flickr.com/photos/hailey-
heaton

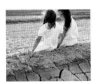

PLATE 56
MÉLANIE RODRIGUEZ
www.melanierodriguez.eu

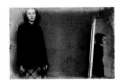

PLATE 60
ROBERT HUTINSKI
www.robert-hutinski.com

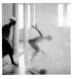

PLATE 64
FLORENCE DOUYROU
www.florencedouyrou.com

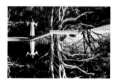

PLATE 65
AMANDA CHARCHIAN
www.amandacharchian.com

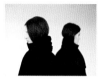

PLATE 67
NICOLAS SISTO
www.sistonicolas.com

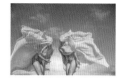

PLATE 69
PRUE STENT
www.pruestent.com

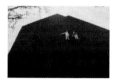

PLATE 71
POLLY GAILLARD
www.pollygaillard.com

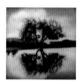

PLATE 66
RAY CAROFANO
www.carofano.com

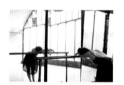

PLATE 68
SHINI PARK OF PARK & CUBE
www.parkandcube.com

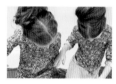

PLATE 70
PAULA PERRIER
www.paulaperrier.com

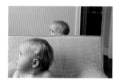

PLATE 72
POLLY GAILLARD
www.pollygaillard.com

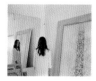

PLATE 73
JASMINE DEPORTA
www.jasminedeporta.com